DRAW 50

Magical Creatures

The Step-by-Step Way to Draw Unicorns, Elves, Cherubs, Trolls, and Many More . . .

BOOKS IN THIS SERIES

- *Draw 50 Airplanes, Aircraft, and Spacecraft*
- *Draw 50 Aliens*
- *Draw 50 Animal 'Toons*
- *Draw 50 Animals*
- *Draw 50 Athletes*
- *Draw 50 Baby Animals*
- *Draw 50 Beasties*
- *Draw 50 Birds*
- *Draw 50 Boats, Ships, Trucks, and Trains*
- *Draw 50 Buildings and Other Structures*
- *Draw 50 Cars, Trucks, and Motorcycles*
- *Draw 50 Cats*
- *Draw 50 Creepy Crawlies*
- *Draw 50 Dinosaurs and Other Prehistoric Animals*
- *Draw 50 Dogs*
- *Draw 50 Endangered Animals*
- *Draw 50 Famous Cartoons*
- *Draw 50 Flowers, Trees, and Other Plants*
- *Draw 50 Horses*
- *Draw 50 Magical Creatures*
- *Draw 50 Monsters*
- *Draw 50 People*
- *Draw 50 Princesses*
- *Draw 50 Sharks, Whales, and Other Sea Creatures*
- *Draw 50 Vehicles*
- *Draw the Draw 50 Way*

DRAW 50

Magical Creatures

The Step-by-Step Way to Draw Unicorns, Elves, Cherubs, Trolls, and Many More . . .

LEE J. AMES
with Andy Mitchell

Watson-Guptill Publications, New York

Copyright © 2009 by Jocelyn S. Ames and Murray D. Zak

Published in the United States by Watson-Guptill Publications,
an imprint of the Crown Publishing Group, a division of Random
House, Inc., New York, in 2013.

www.crownpublishing.com
www.watsonguptill.com

WATSON-GUPTILL and the WG and Horse designs are
registered trademarks of Random House, Inc.

Originally published in hardcover in the United States by
Broadway Books, an imprint of the Crown Publishing Group,
a division of Random House Inc., New York, in 2009.

Library of Congress Cataloging-in-Publication Data

Ames. Lee J.
 Draw 50 magical creatures : the step-by-step way to draw
unicorns, elves, cherubs,
Trolls, and many more / Lee J. Ames and Andrew Mitchell.— 1st ed.
 p. cm. — (Draw 50 magical creatures)
 1. Fantasy in art. 2. Drawing—Technique. I. Mitchell, Andrew J.,
1967—
II. Title. III. Title: Draw fifty magical creature. IV. Series.

 NC825.F25A44 2009
 743'.87—dc22

ISBN 978-0-8230-8610-8
eISBN 978-0-8230-8611-5

Printed in the United States of America

10 9 8 7 6 5 4 3 2 1

For Alison Sally, Jonathan David, and their families and pets...

To the Reader

Before you begin drawing, here are some tips on how to use and enjoy this book:

When you start working, use clean white bond paper or drawing paper and a pencil with moderately soft lead (HB or No.2). Have a kneaded eraser on hand (available at art supply stores). Choose any one of the subjects in the book that you want to draw and then very lightly and very carefully sketch out the first step. As you do so, study the finished step of your chosen drawing to sense how your first step will fit in. Make sure the size of the first step is not so small that the final drawing will be tiny, or so large that you won't be able to fit the finished drawing on the paper. Then, also very lightly and very carefully, sketch out the second step. Carefully focus on each step to see how it fits into both the previous, and the following step. You must also focus on the final drawing to see how each step is a part of it. As you go along, step by step, study not only the lines but also the size of the spaces between lines. Remember, the first steps must be constructed with the greatest care. A wrongly placed stroke could throw the whole drawing off.

As you work, it is a good idea to have a mirror available. Holding your sketch up to the mirror from time to time can show you distortions you might not see otherwise.

As you are adding to the steps, you may discover that they are becoming too dark. Here's where the kneaded eraser becomes particularly useful. You can lighten the darker penciling by strongly pressing the clay-like eraser onto the dark areas.

When you've put it all together and gotten to the last step, finish the drawing firmly with dark, accurate strokes. There is your finished drawing. However, if you want to further finish the drawing with India ink, applied with a pen or fine brush, you can clean out all of the penciling with a kneaded eraser after the ink completely dries.

Remember, if your first attempts do not turn out too well, it's important to keep trying. Practice and patience do indeed help. I would like you to know that on occasion when I have used the steps for a drawing from one of my own books, it has taken me as long as an hour or two to bring it to a finish.

—Lee J. Ames

DRAW 50 MAGICAL CREATURES

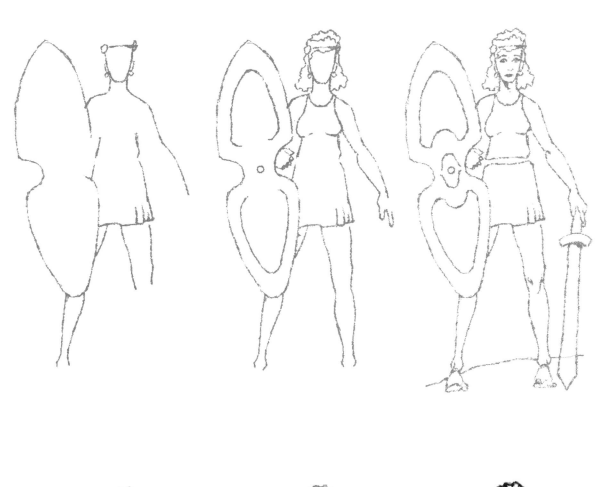

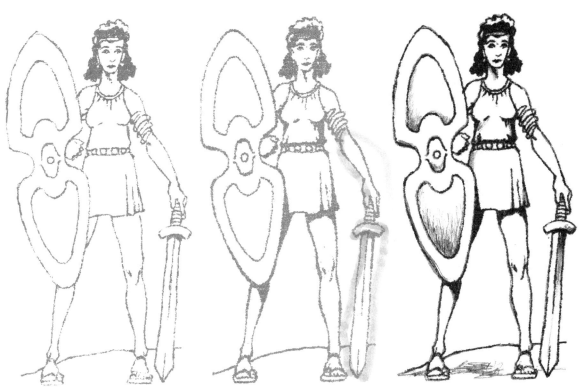

Amazon

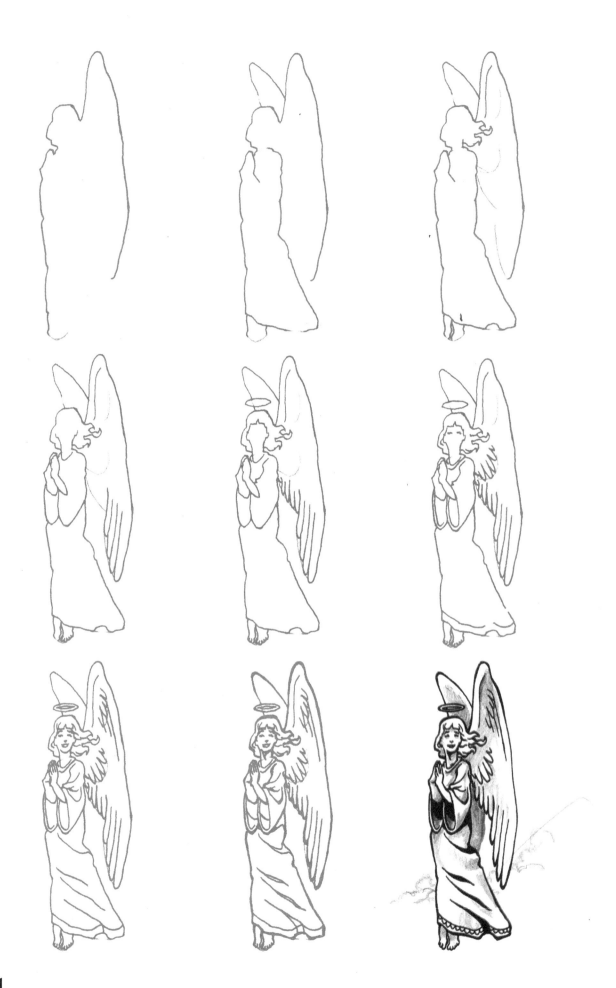

Angel

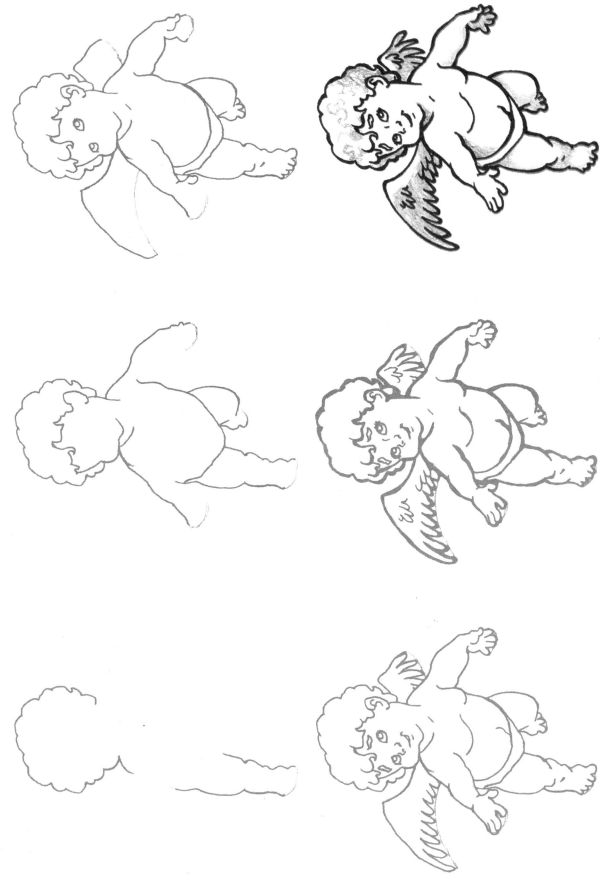

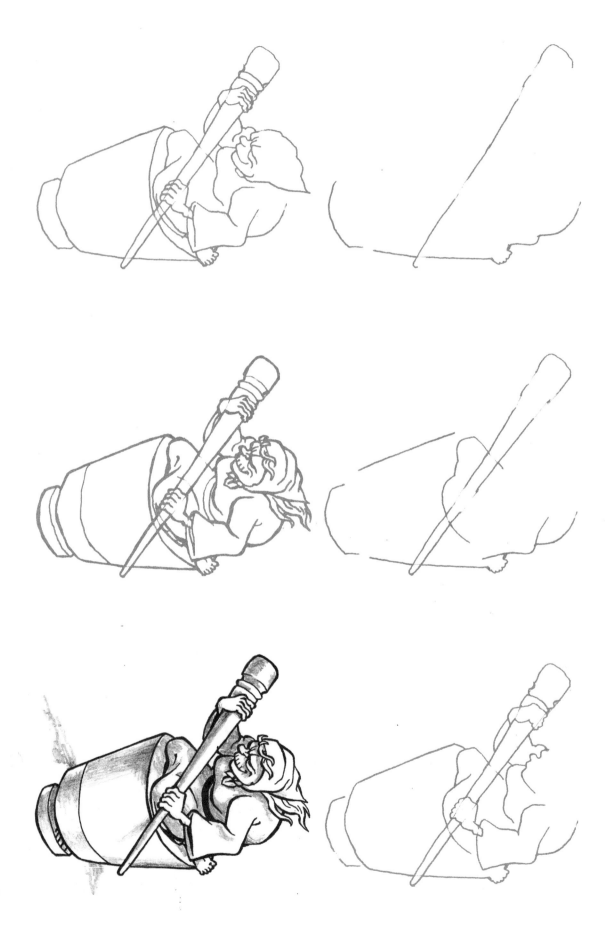

Baba Yaga

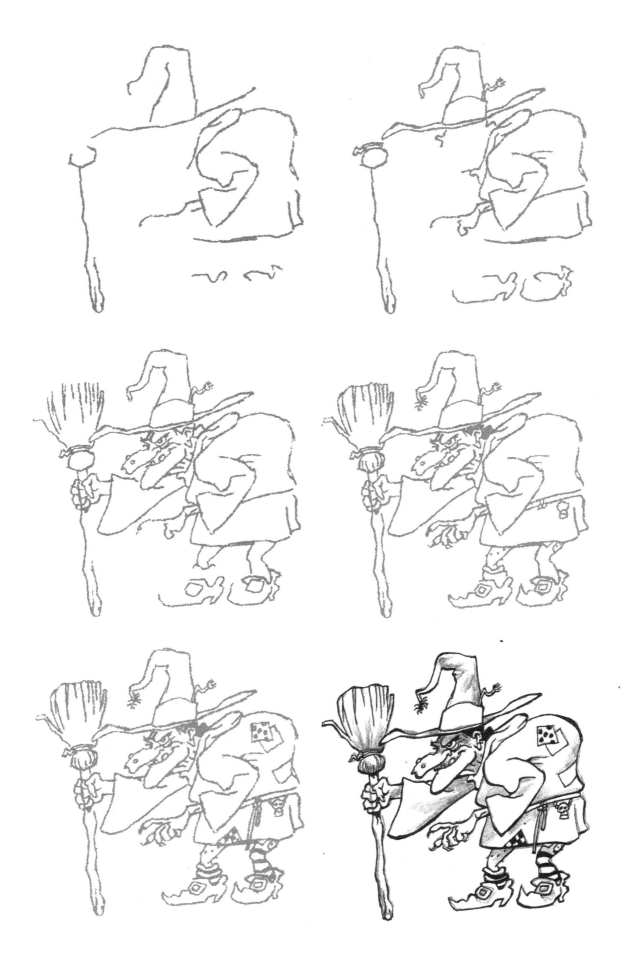

Bad Witch

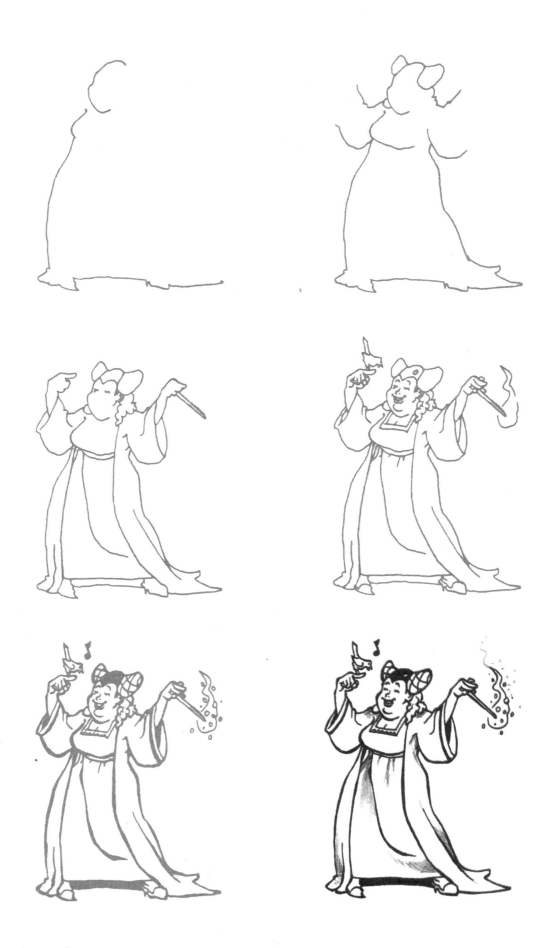

The Good Witch

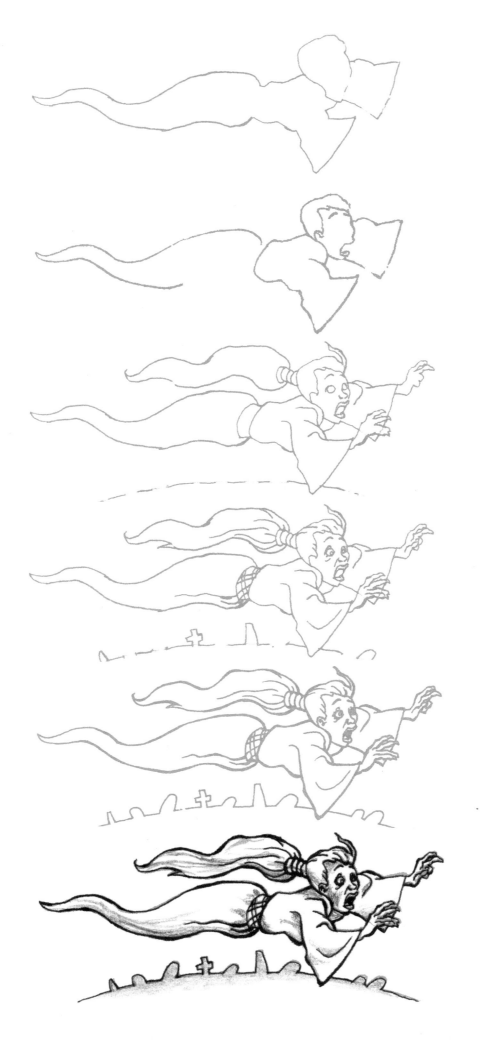

Banshee

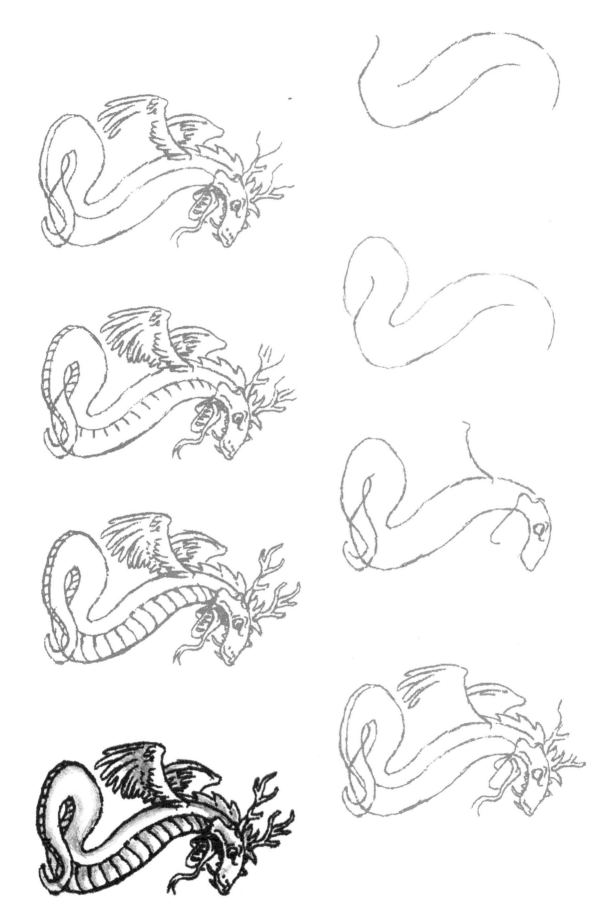

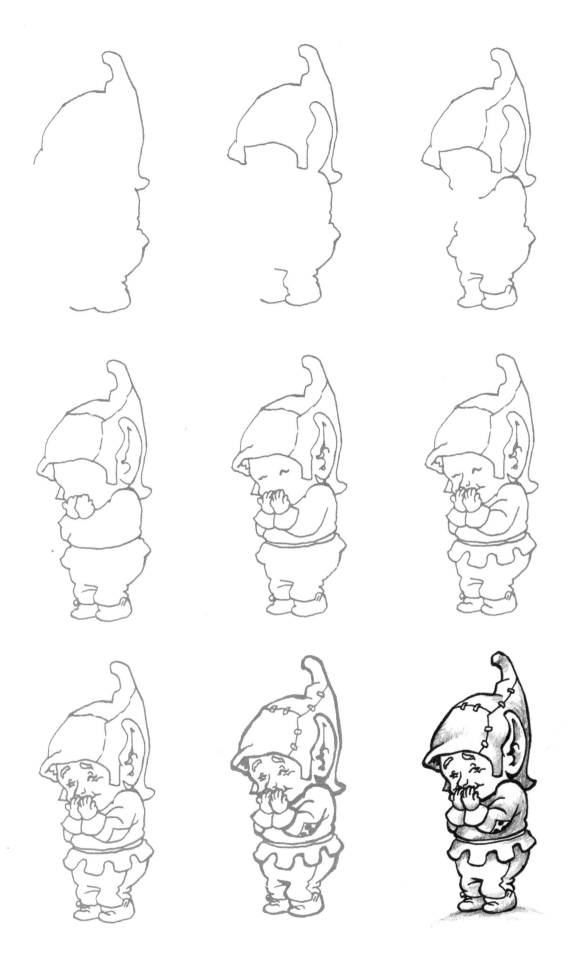

Brownie

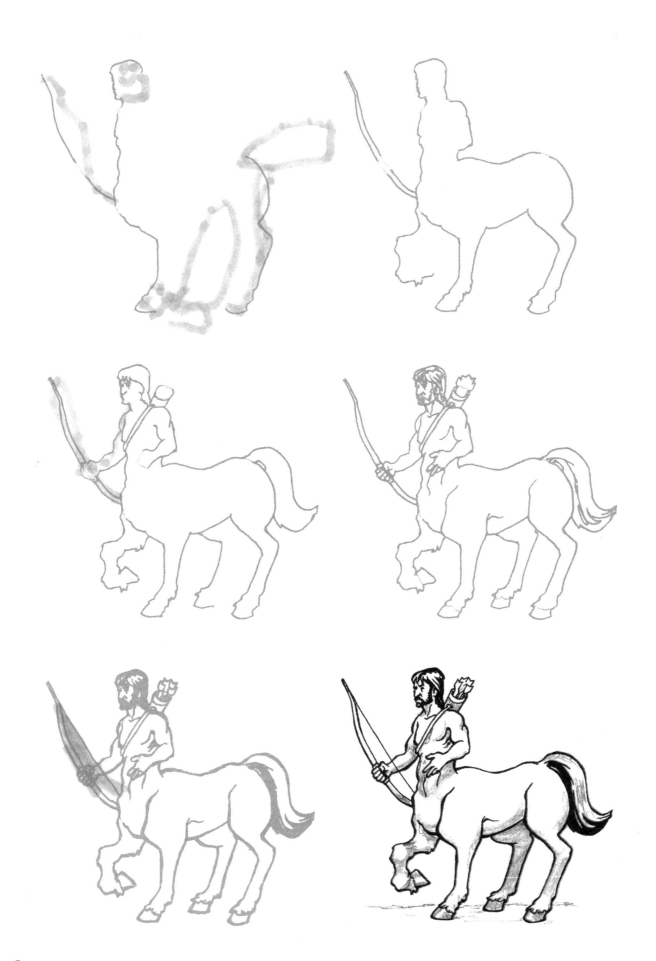

Centaur

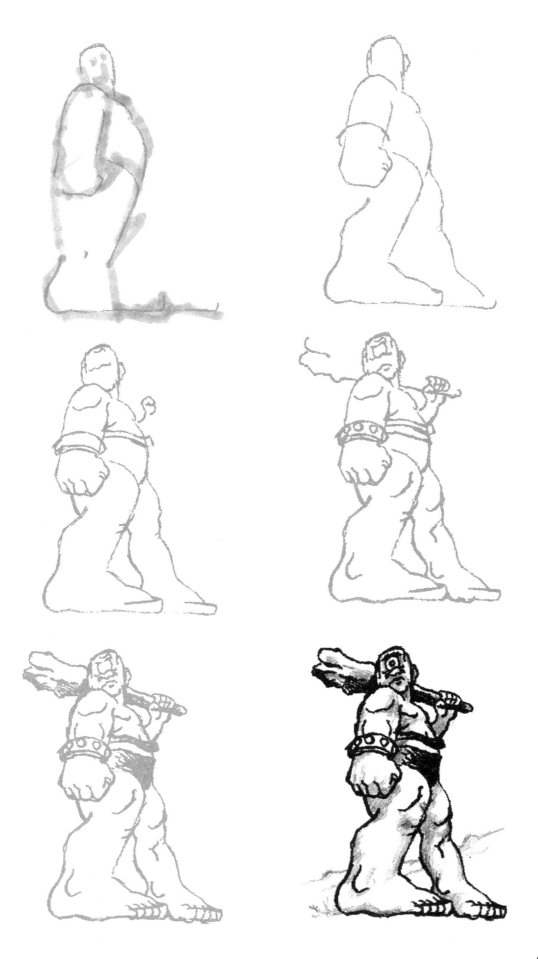

Cyclops

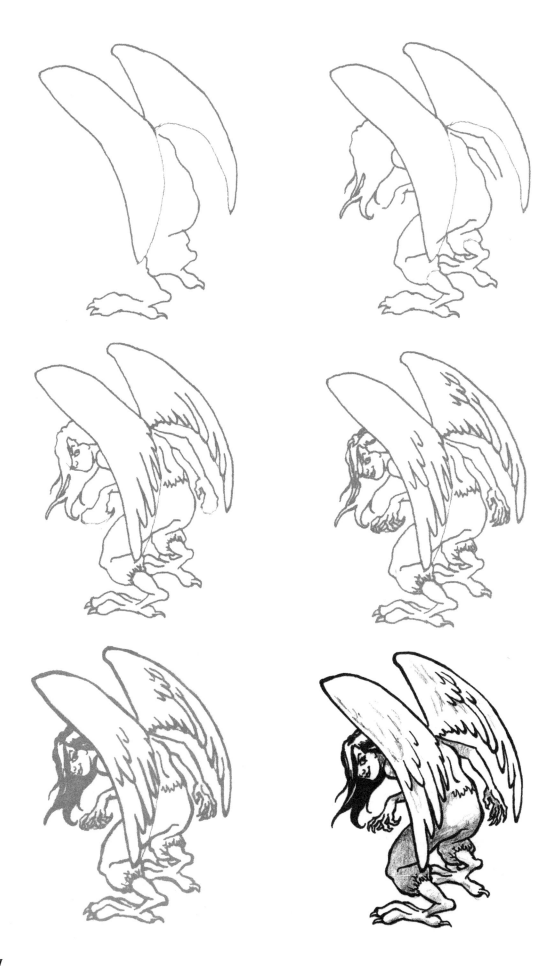

Harpy

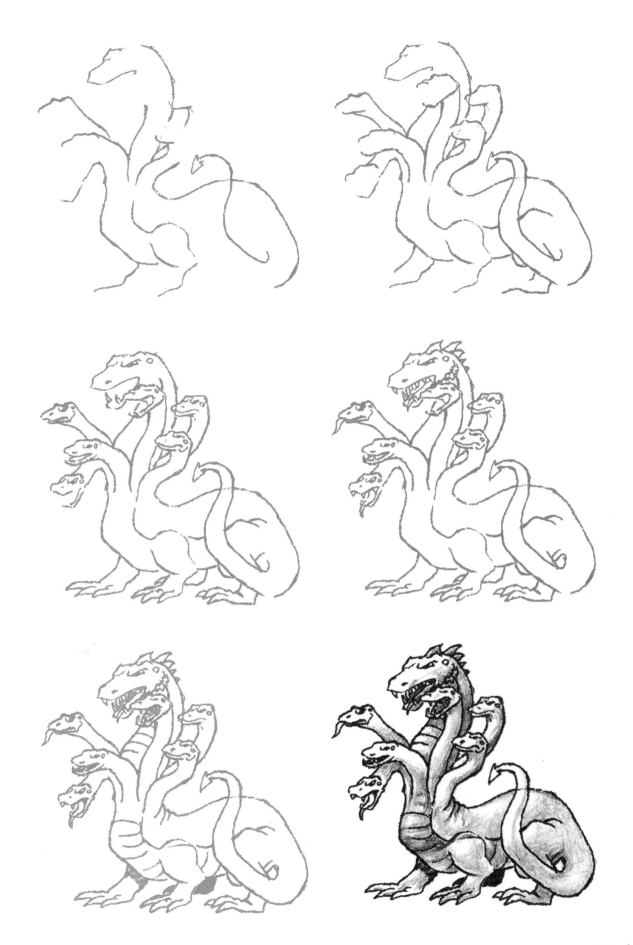

Hydra

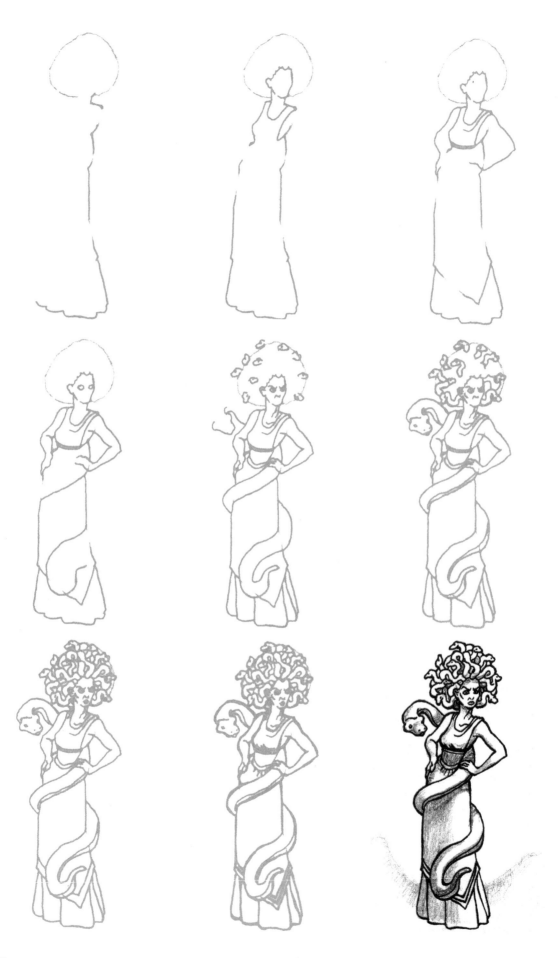

Medusa

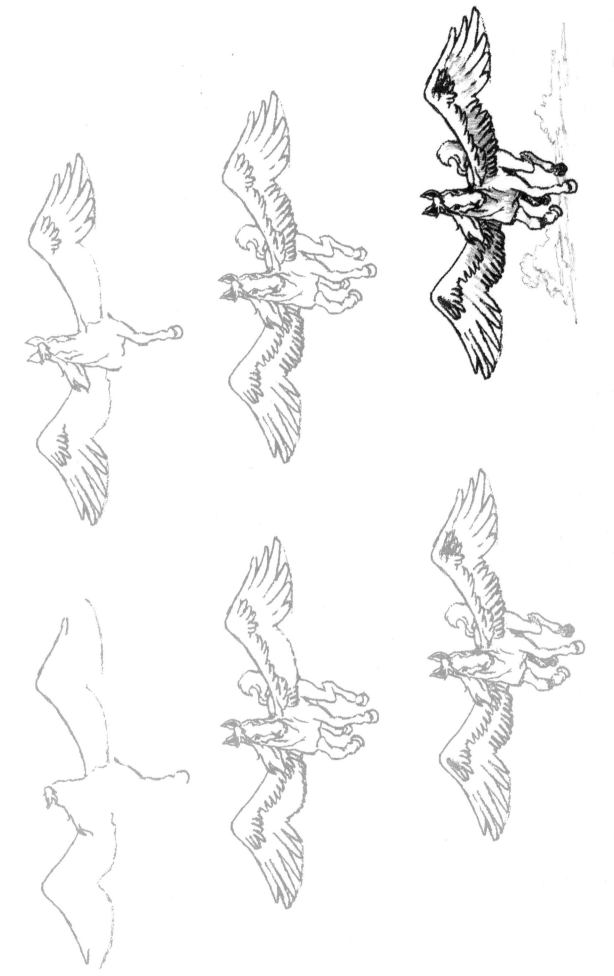

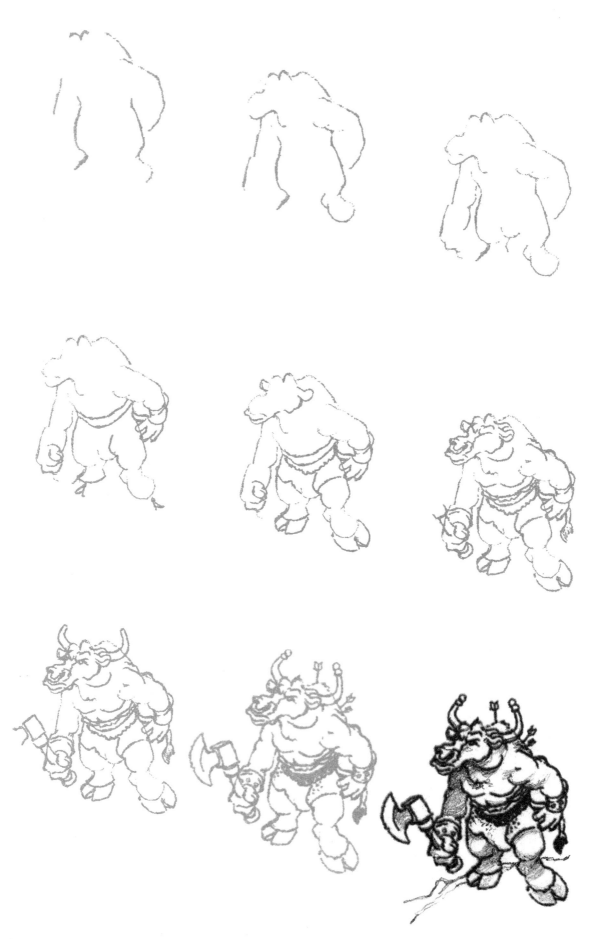

Minotaur

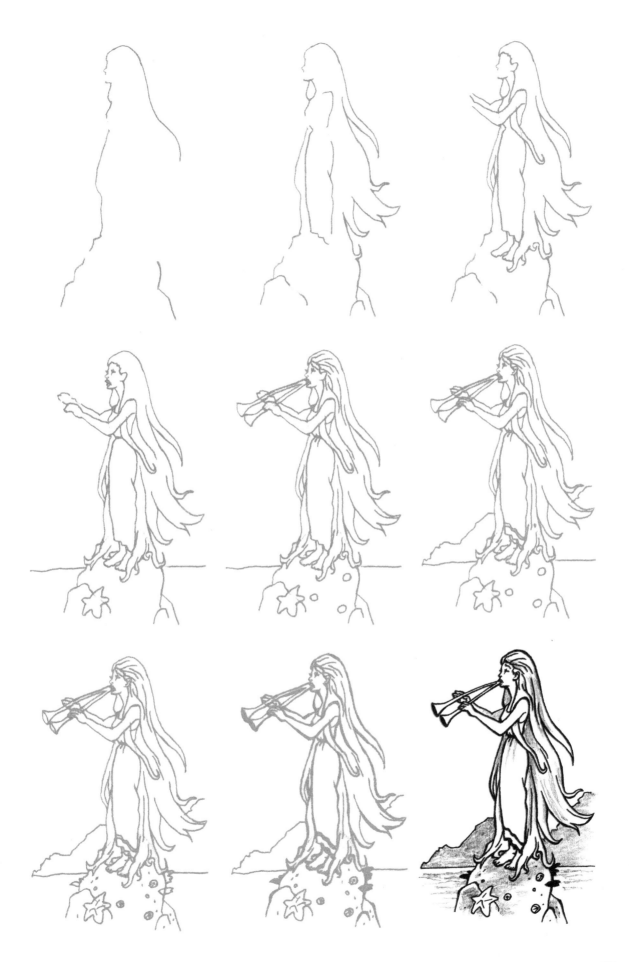

Siren

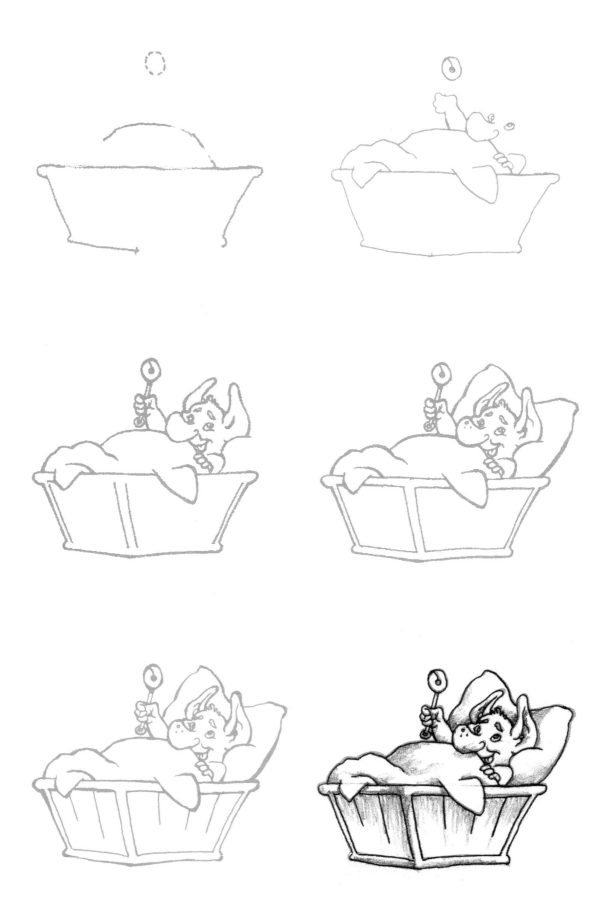

Changeling

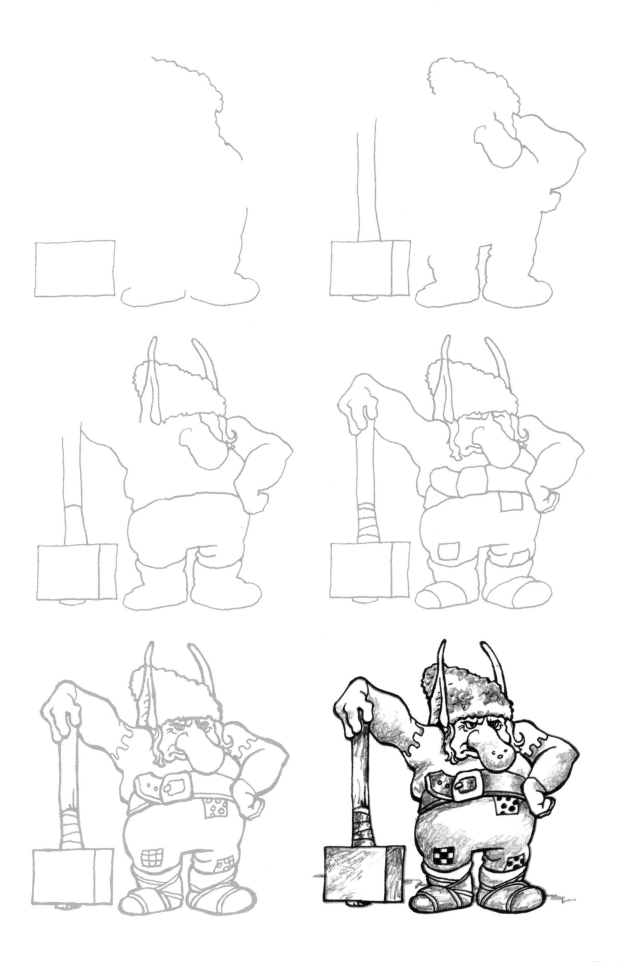

Troll

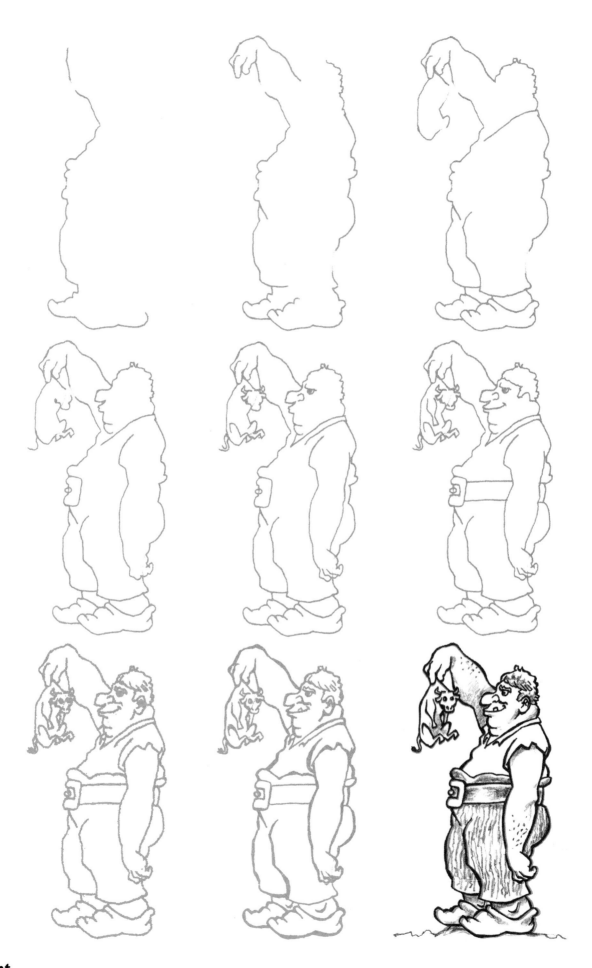

Giant

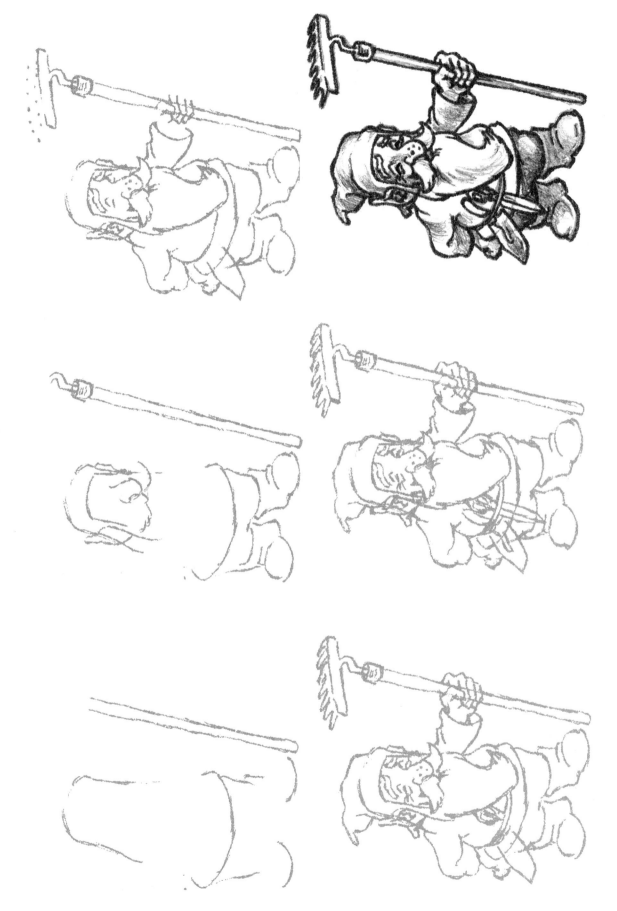

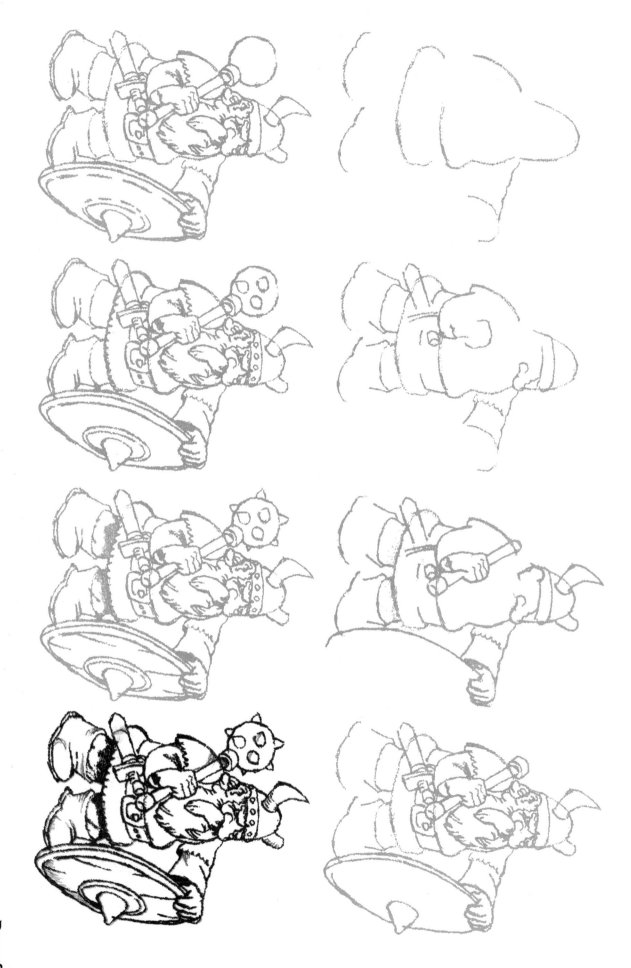

Dwarf

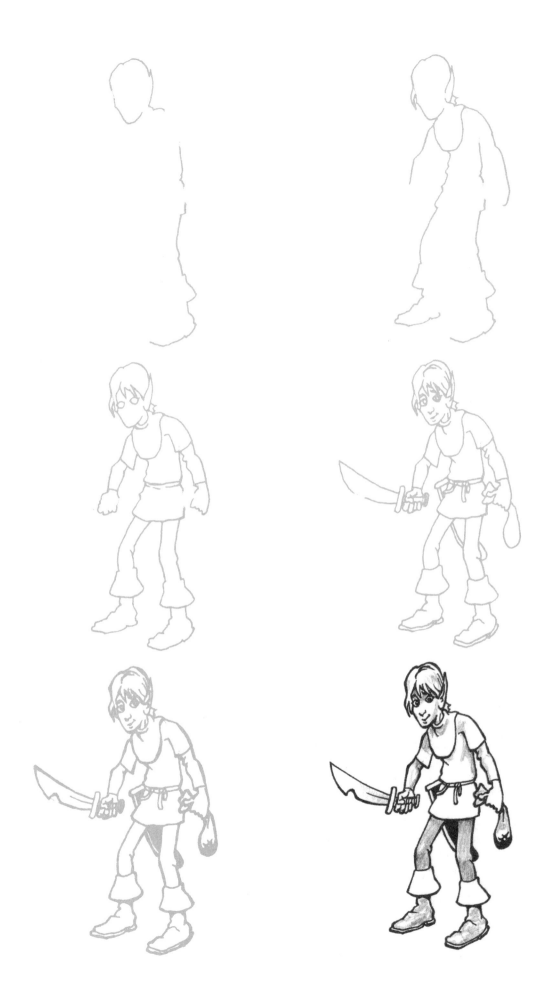

Elf

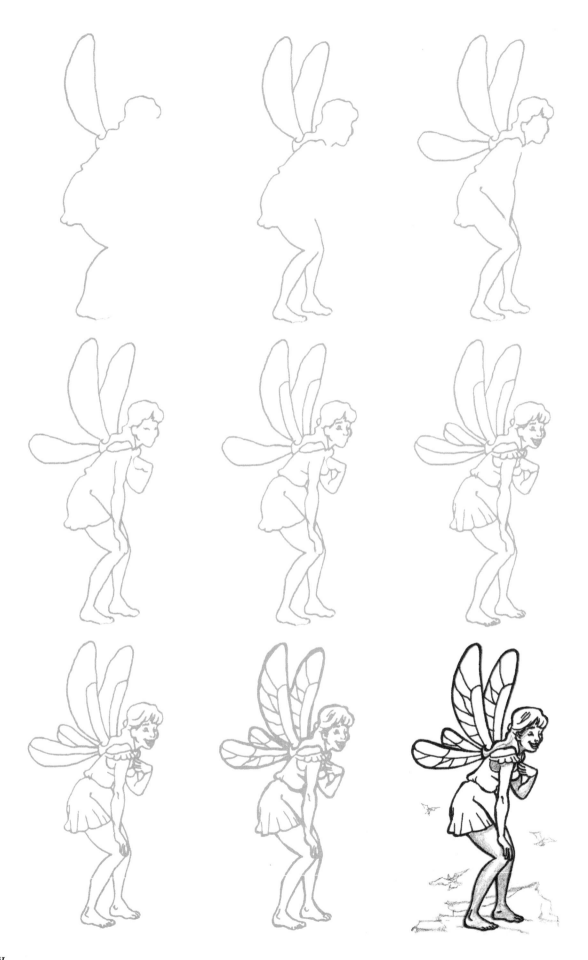

Fairy

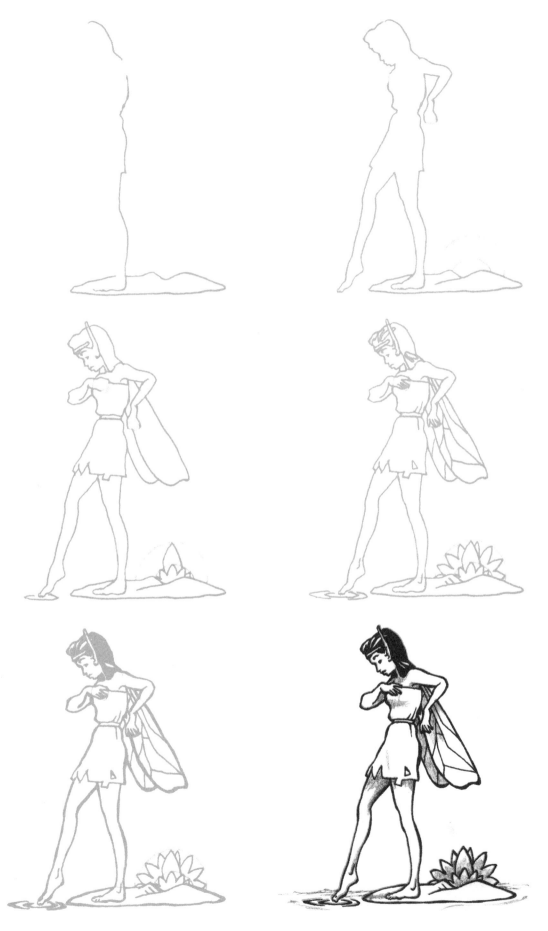

Water Fairy

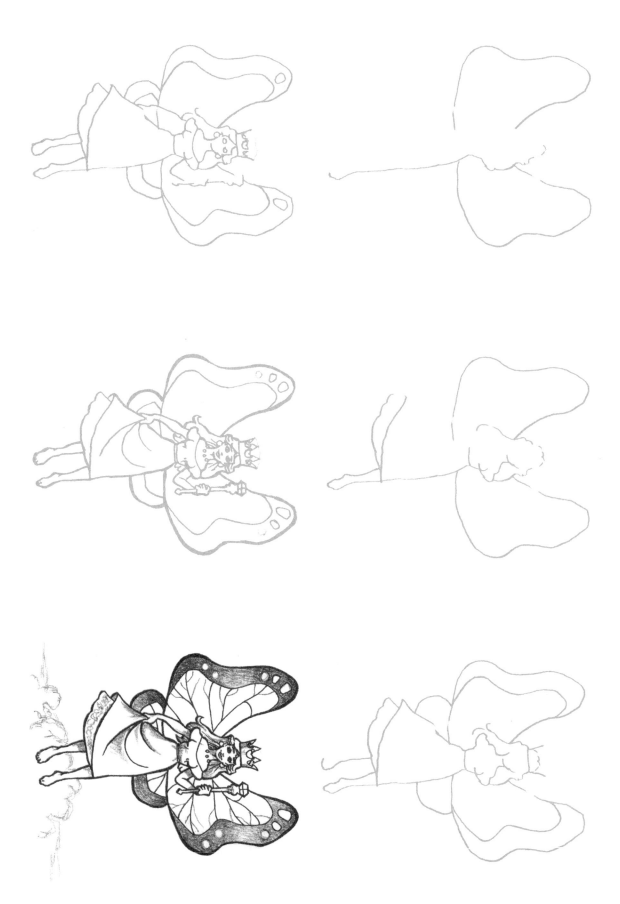

Fairy Queen

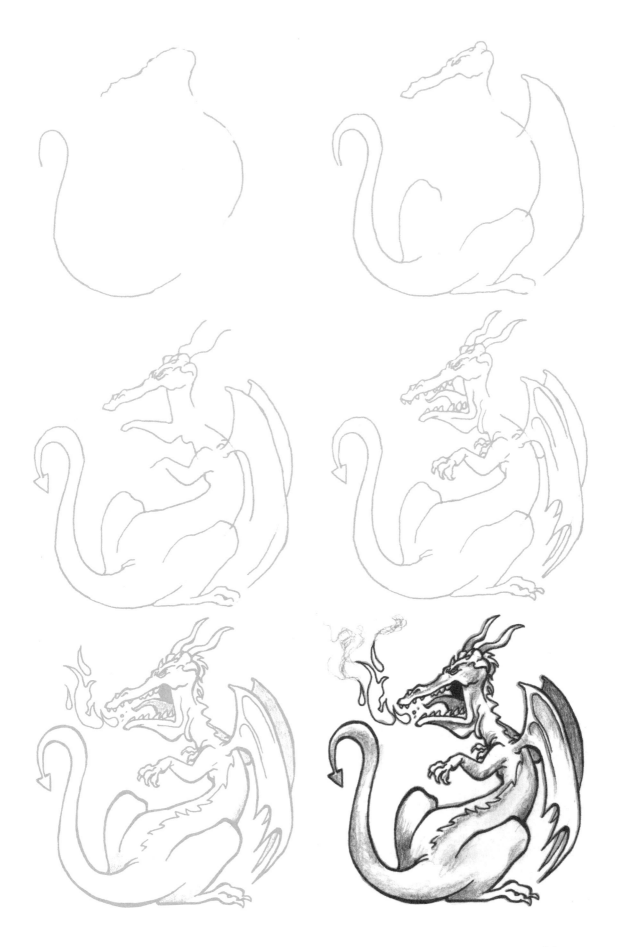

Fire-Breathing Dragon

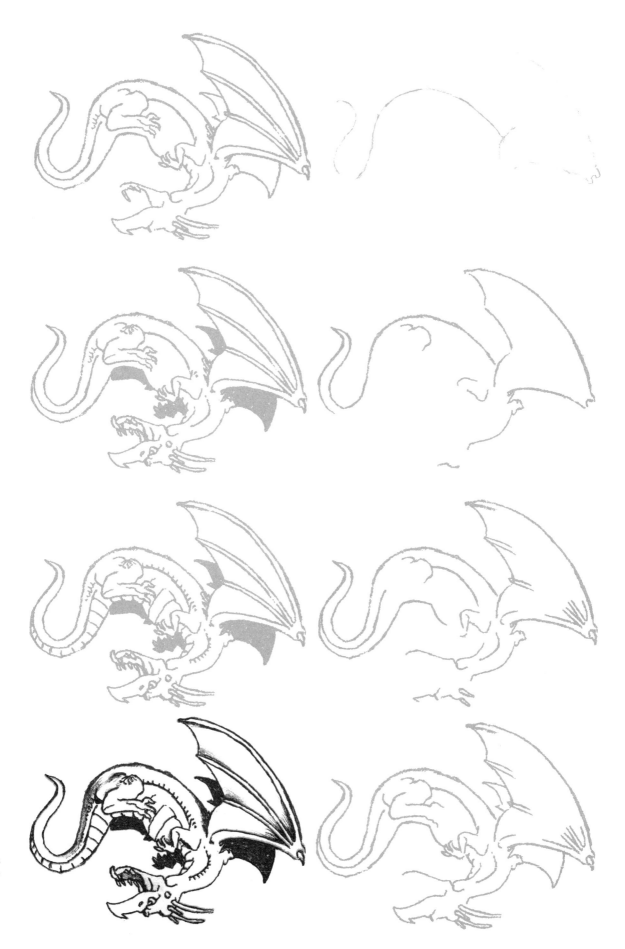

Flying Dragon

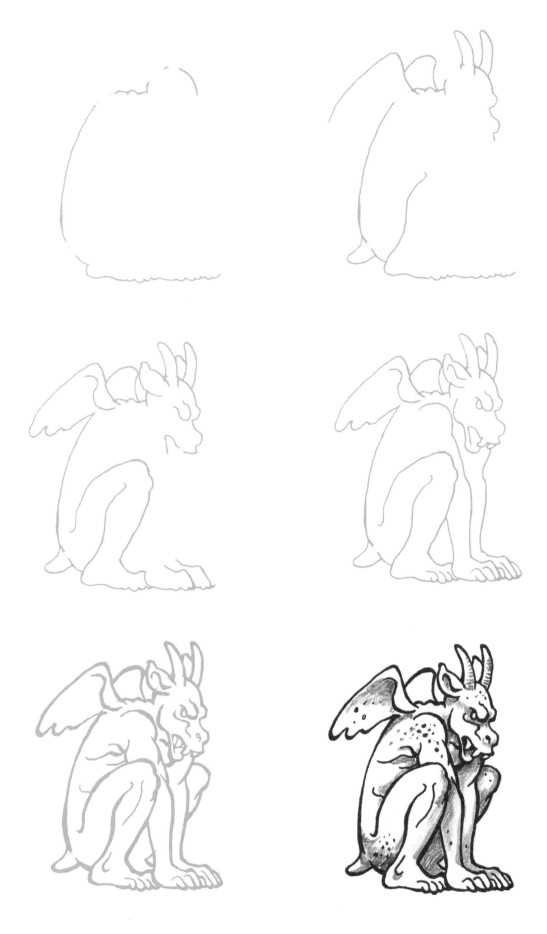

Gargoyle

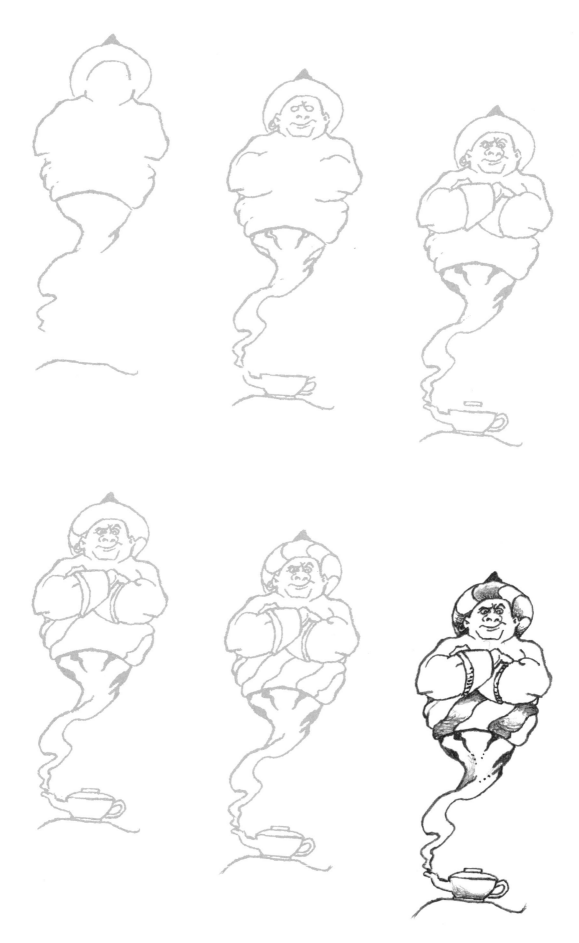

Genie

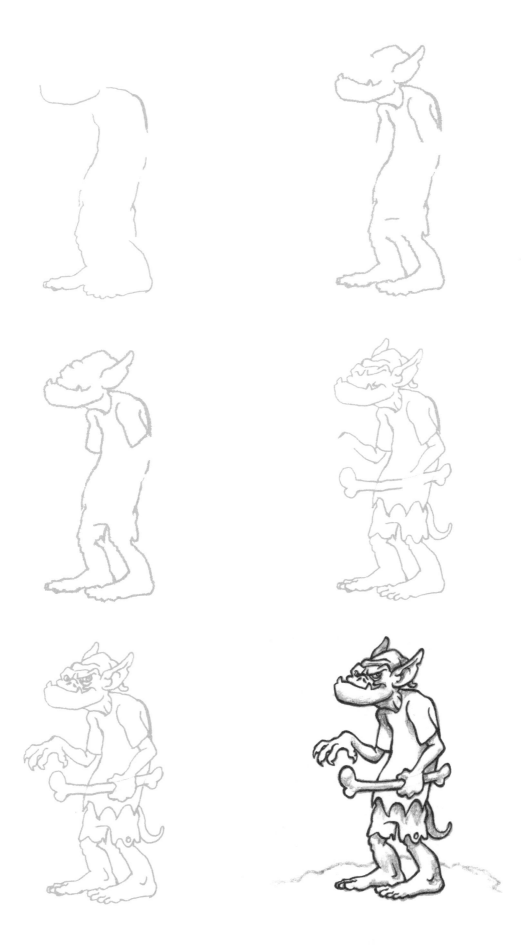

Goblin

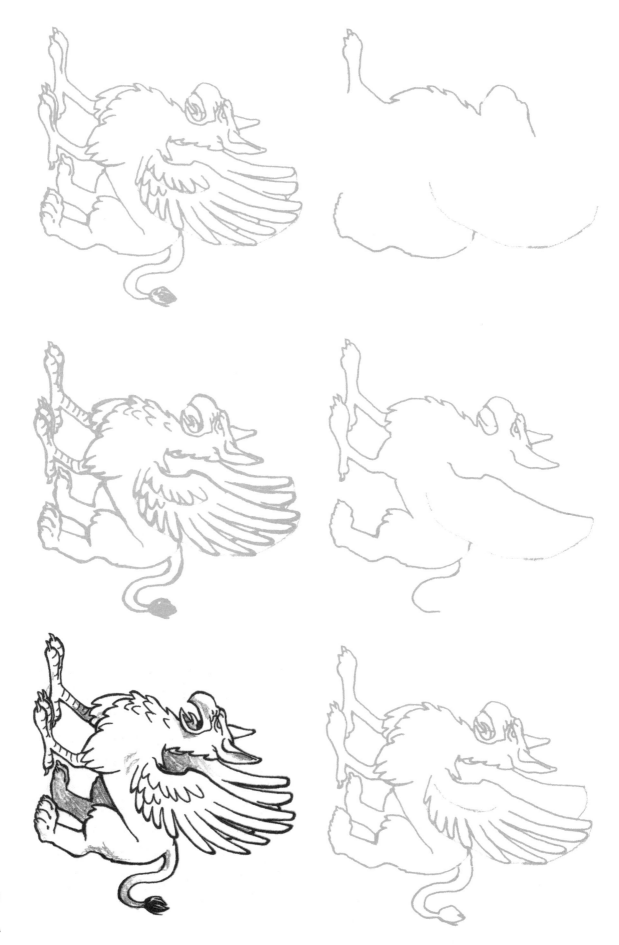

Gryphon

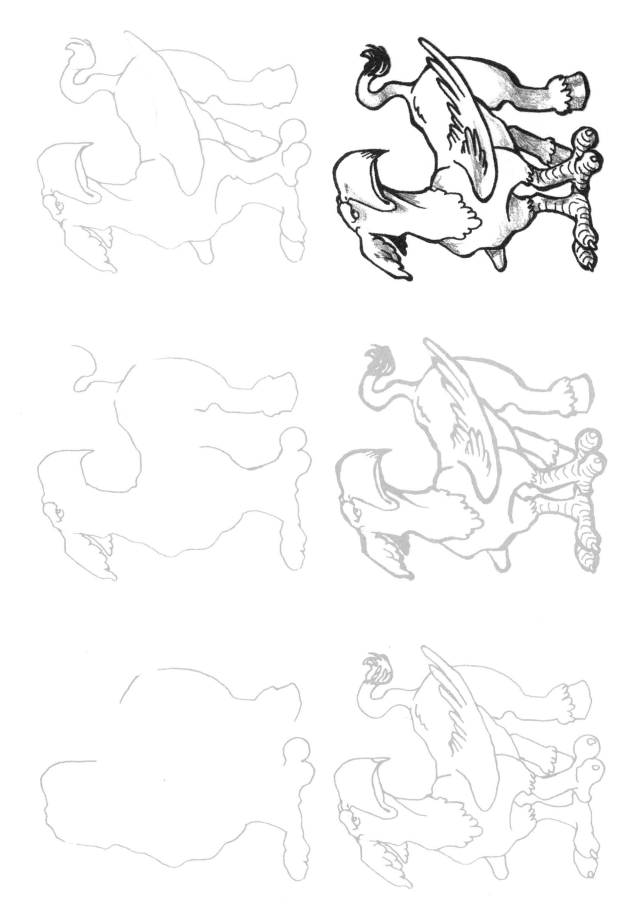

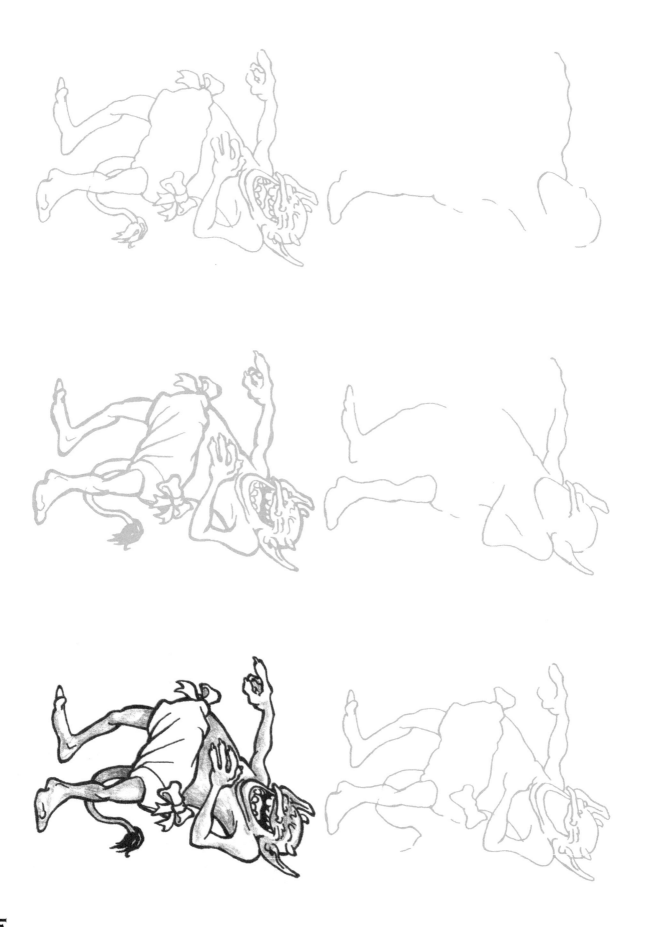

Imp

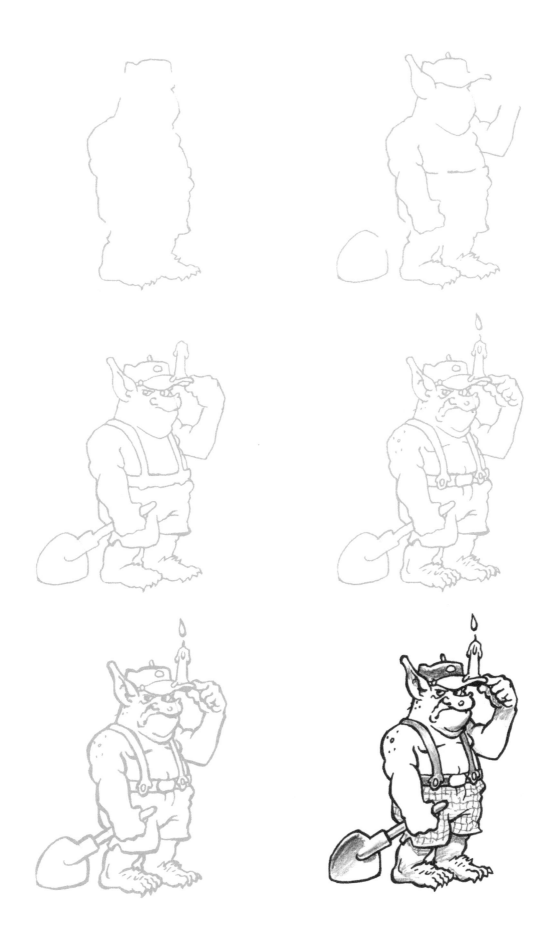

Kobold

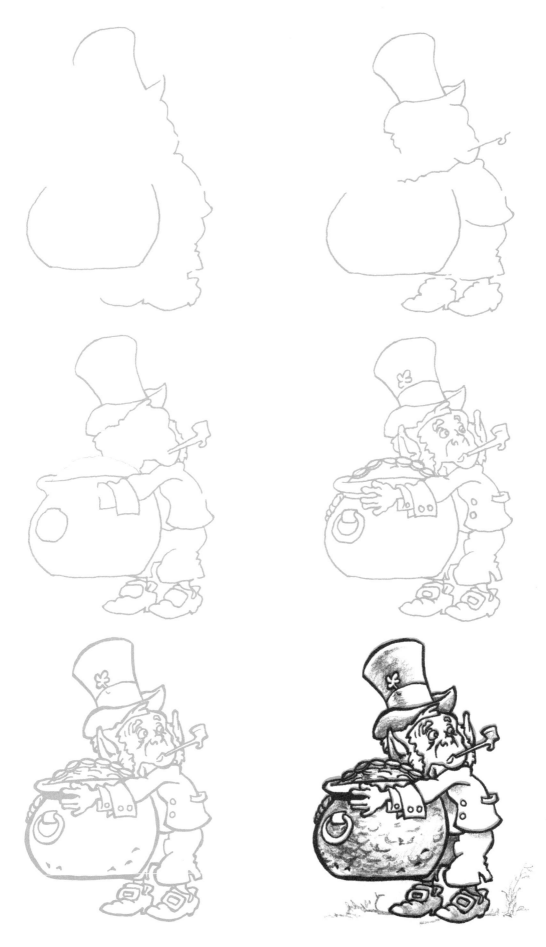

Leprechaun

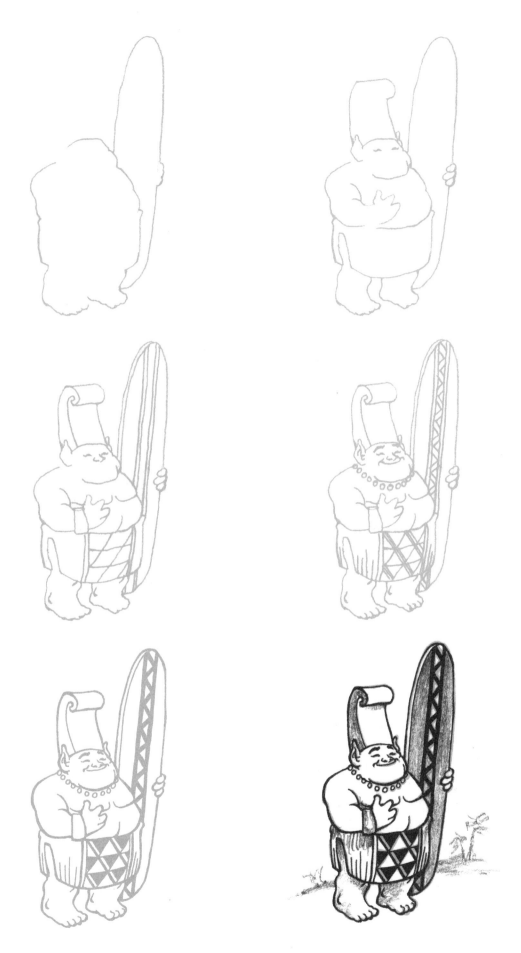

Menehune

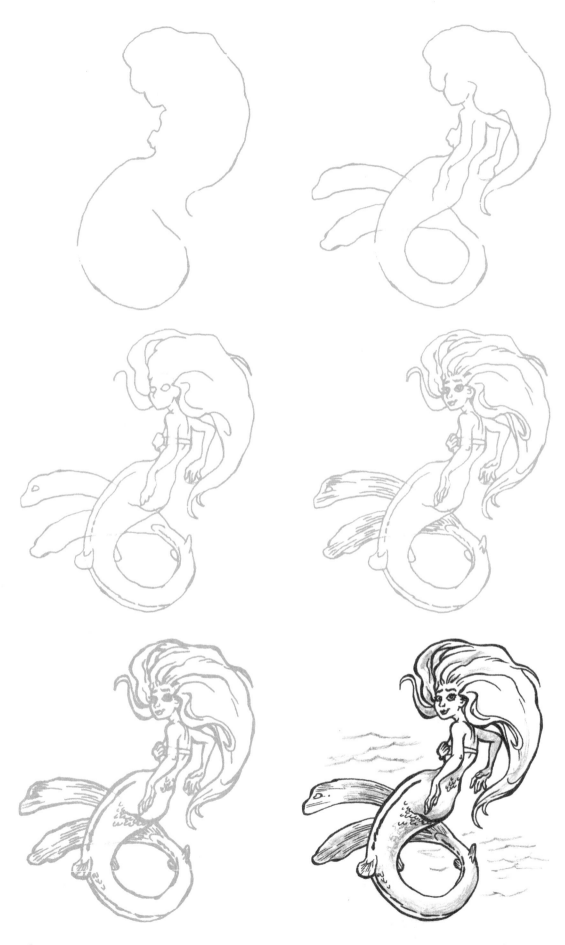

Mermaid

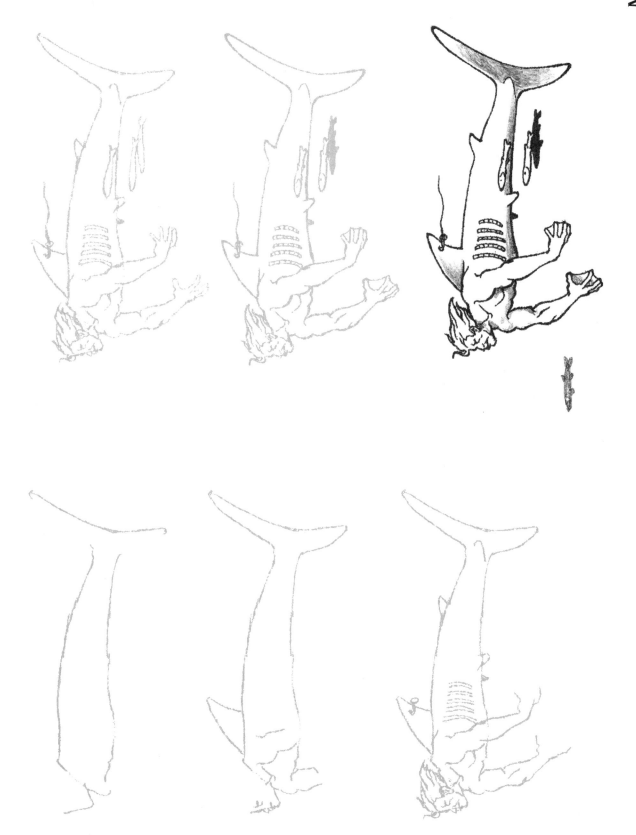

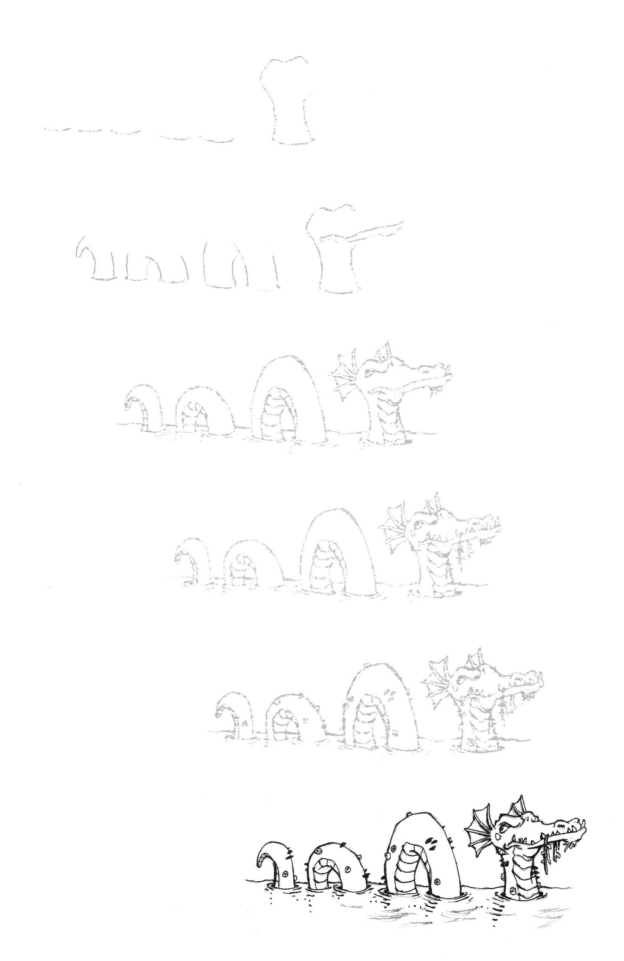

Sea Serpent

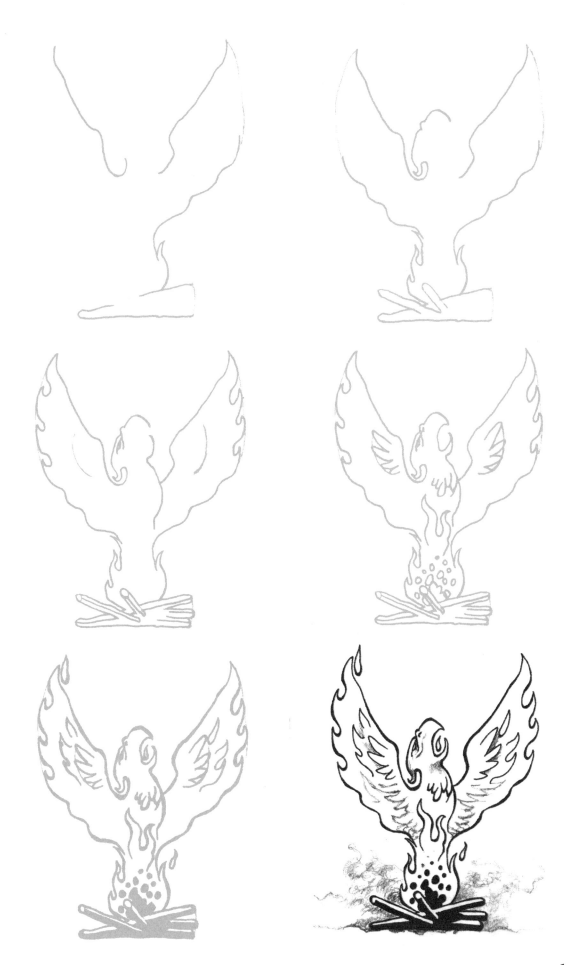

Phoenix

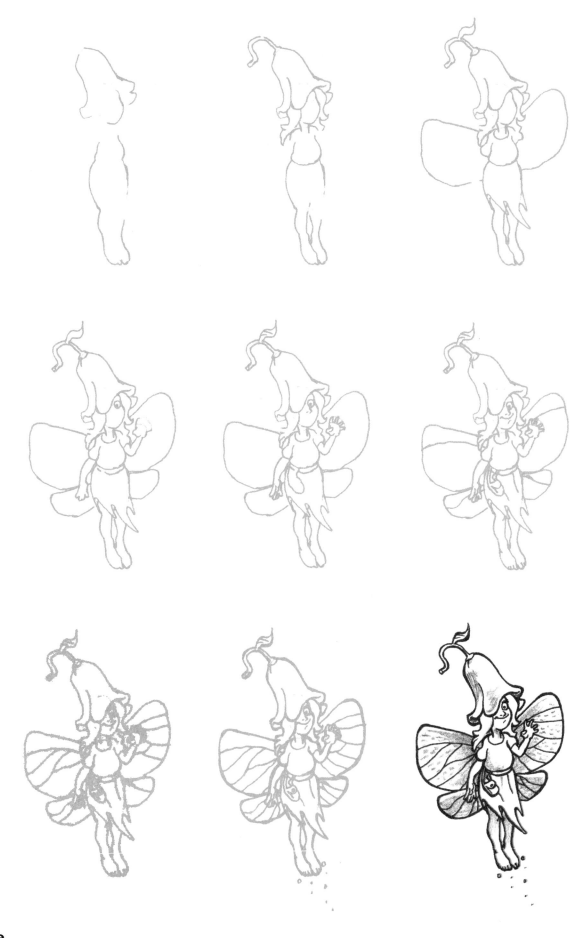

Pixie

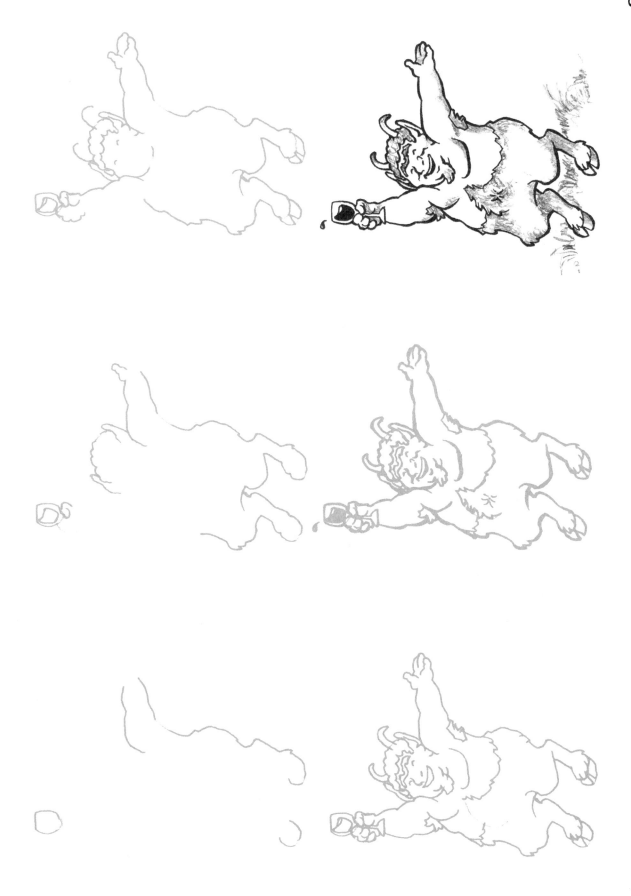

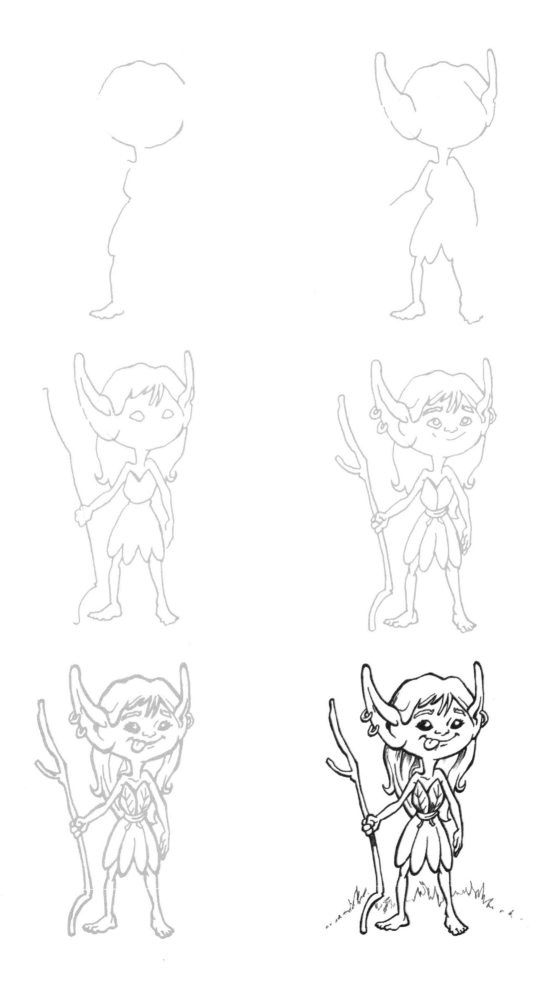

Sprite

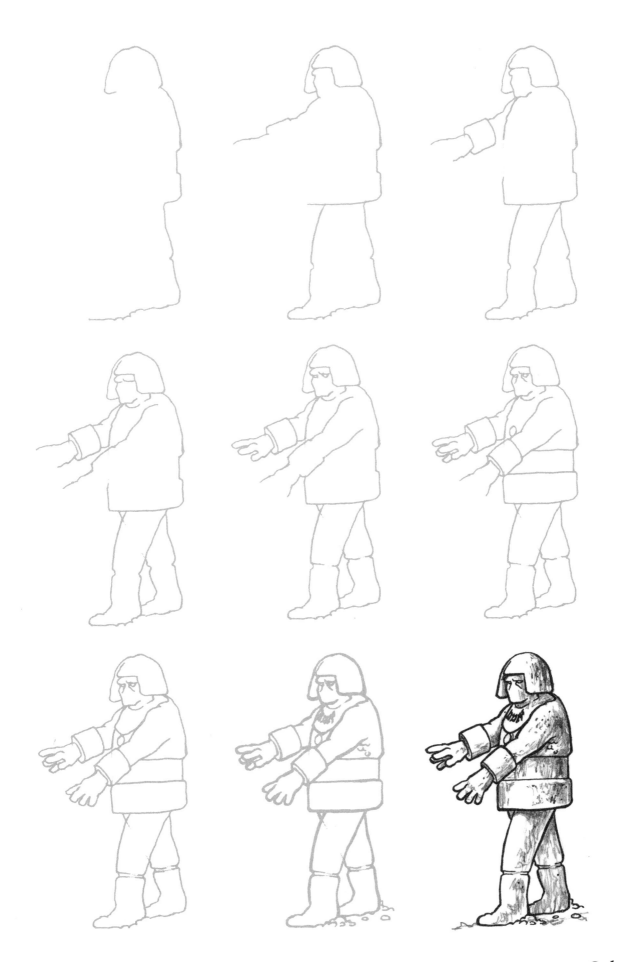

Golem

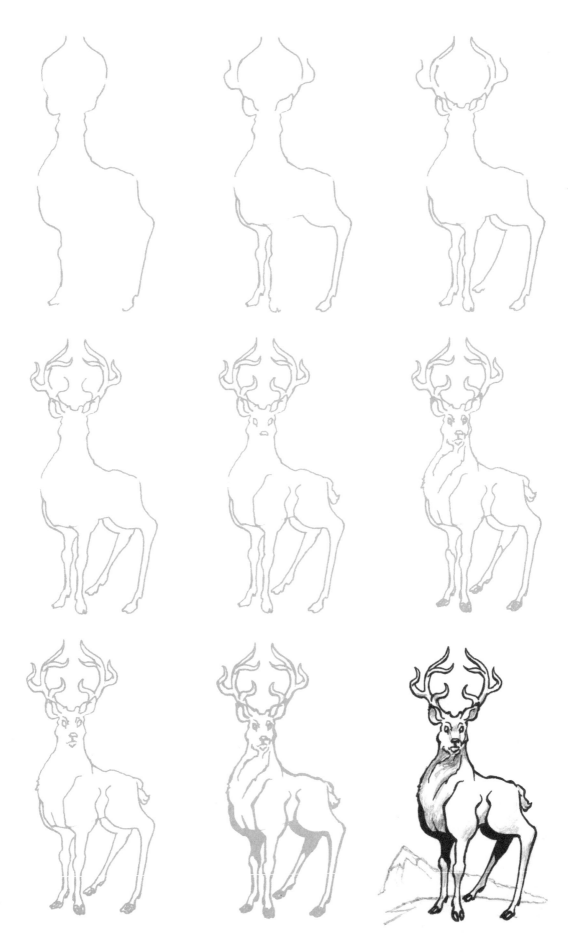

Golden Stag

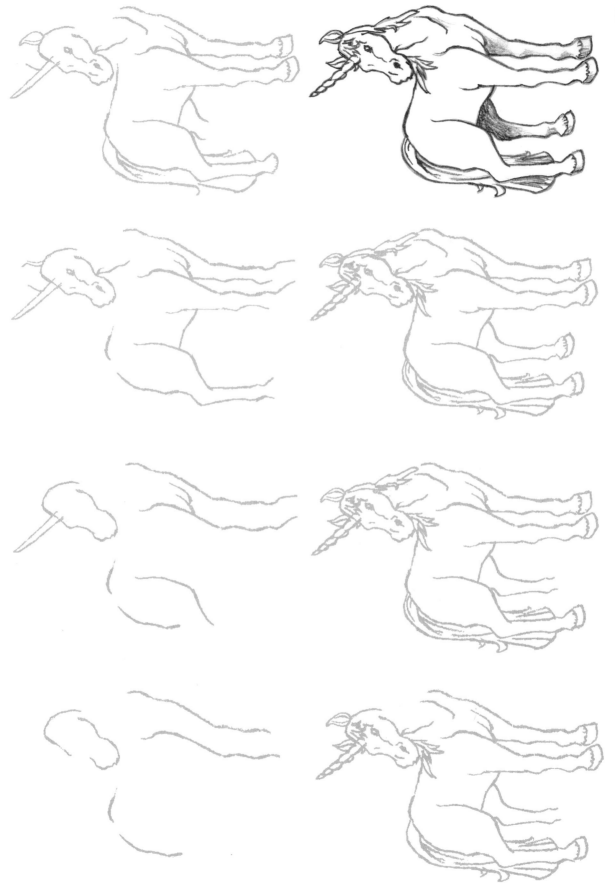

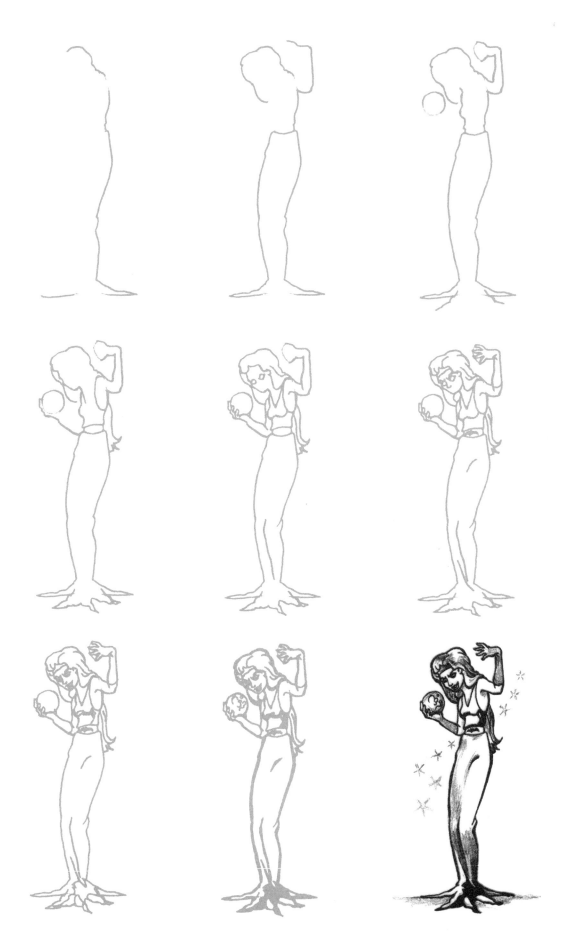

Sorceress

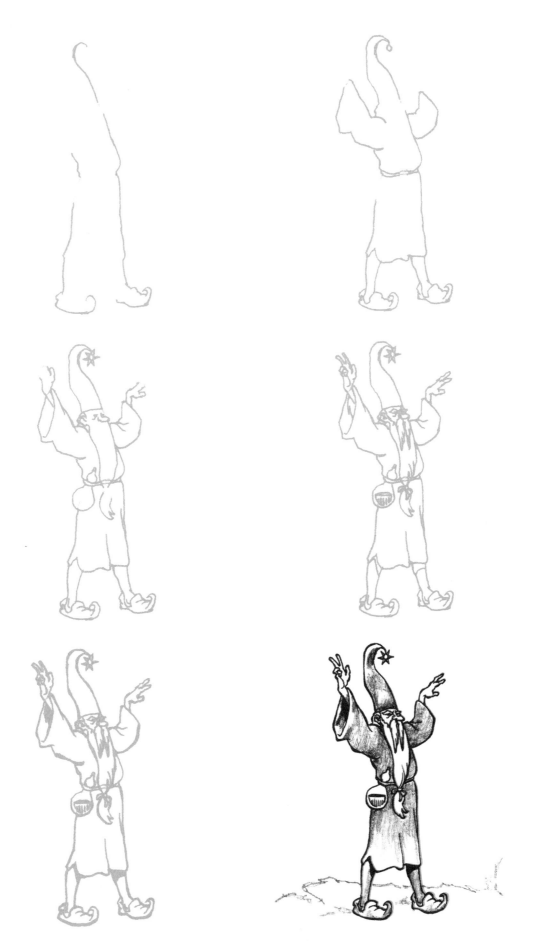

Wizard

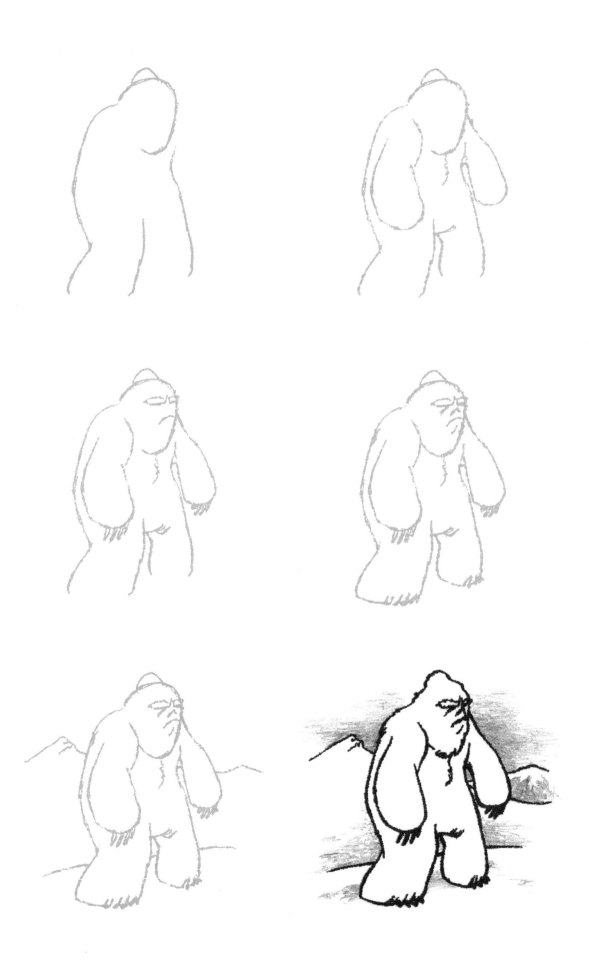

Yeti

Lee J. Ames began his career at the Walt Disney Studios, working on films that included *Fantasia* and *Pinocchio*. He taught at the School of Visual Arts in Manhattan, and at Dowling College on Long Island, New York. An avid worker, Ames directed his own advertising agency, illustrated for several magazines, and illustrated approximately 150 books that range from picture books to postgraduate texts. He resided in Dix Hills, Long Island, with his wife, Jocelyn, until his death in June 2011.

Andy Mitchell has drawn and painted for books, magazines, video games, and newspapers. He is president of the Cartoonists of Orange Country and resides in Southern California.

DRAW 50 MAGICAL CREATURES

Experience All That the Draw 50 Series Has to Offer!

With this proven, step-by-step method, Lee J. Ames has taught millions how to draw everything from amphibians to automobiles. Now it's your turn! Pick up the pencil, get out some paper, and learn how to draw everything under the sun with the Draw 50 series.

Also Available:

- *Draw 50 Aliens*
- *Draw 50 Animals*
- *Draw 50 Animal 'Toons*
- *Draw 50 Athletes*
- *Draw 50 Baby Animals*
- *Draw 50 Beasties*
- *Draw 50 Birds*
- *Draw 50 Boats, Ships, Trucks, and Trains*
- *Draw 50 Cats*
- *Draw 50 Cars, Trucks, and Motorcycles*
- *Draw 50 Creepy Crawlies*
- *Draw 50 Dinosaurs and Other Prehistoric Animals*
- *Draw 50 Dogs*
- *Draw 50 Endangered Animals*
- *Draw 50 Famous Cartoons*
- *Draw 50 Flowers, Trees, and Other Plants*
- *Draw 50 Horses*
- *Draw 50 Monsters*
- *Draw 50 People*
- *Draw 50 Princesses*
- *Draw 50 Sharks, Whales, and Other Sea Creatures*
- *Draw 50 Vehicles*
- *Draw the Draw 50 Way*